Praise for *The Autobiography of Rain*

Ayers catches ephemeral moments in lines and in deft strokes as the poems in *The Autobiography of Rain* affix these instants onto monuments. The fickle and atmospheric weather of losses, revelations, and heartbreak shifts and shimmers. Meanwhile, the residue of a night of rain on pavement reflects what is brightest about the sun. These gorgeous poems reside in the heartbeat-sound of showers on a roof as well as the dazzle of the world after the rain. They bedazzle and go from gray to glow.

—OLIVER DE LA PAZ
author of *The Diaspora Sonnets*

In the beautifully titled *The Autobiography of Rain*, Lana Hechtman Ayers delves into the complex interplay of beauty and grief in the natural world. These engaging poems underscore the restorative power of art and nature, urging readers to cherish life's simple pleasures. With memorable lines such as *Rumor has it the night sky / is composed of crows*, and *This is the year we said "I love you" over and over*, Ayers' voice captivates and draws you in. With keen empathy, Ayers notices the intricacies surrounding us, recognizing how *each sound [is] a unique / song of pain*, all while also celebrating the moments of joy that bring us together—*your voice mingling with mine, more nights, / stars, moons, rain glow, gratitude & its gifts, more joy*. *The Autobiography of Rain* is a gift to readers—each poem in this collection showcases Ayers' remarkable talent for capturing the essence of a moment through vivid imagery and lyrical language. This is a captivating and poignant collection of poems and a must-read for anyone seeking to explore the richness and complexity of the human experience. I could not put this gorgeous collection down.

—KELLI RUSSELL AGODON
author of *Dialogues with Rising Tides*

In Lana Hechtman Ayers new collection, *The Autobiography of Rain*, we are invited not to run for cover from the rain of life but instead to remove our jackets and get wet. In these generous, lyric-narrative poems we find the autobiography of life, the poet's and our own, we find the story of love and grief, of the body and of nature. How lucky to have a poet like Ayers calling out to us in the storm.

—MATTHEW DICKMAN
author of *Husbandry*

Compelling, elegant, and remarkably honest, *The Autobiography of Rain* is filled with stark, realistic poems that paint an intimate portrait of love, loss, family, identity, and the ever-present need for empathy. In these vibrant poems of nature and biography, Ayers showcases a true talent for imbuing the smallest human details with authenticity and layered meanings. Each poem maps out the human heart, in all its internal conflicts, with precision and grace. Overflowing with vivid and accessible language, *The Autobiography of Rain* is both intellectually stimulating and emotionally engaging, reminding us that the *sky above / never leaves us, / never abandons us*.

—JOHN SIBLEY WILLIAMS
author of *The Drowning House*

The best words to describe me are heartbroken, lobelia, starlit, writes Lana Hechtman Ayers, and indeed, her poems surge with aching memories, odes to nature, and the tenuous balance between hope and despair over the troubled state of the world. Despite the *Gordian knot of grief*, as Ayers puts it—*an alphabet of pain*—this can be a *good life, / even when it's frozen / and overcast, / even when the forecast is more of the same*. Weaving from recollections of *golden light all over / the synagogue* to time spent working for a crisis hotline, Ayers shows that poetry can make a difference *in the quiet hours / one kind word at a time*.

—CATHERINE KYLE
author of *Fulgurite*

The Autobiography of Rain

poems

Lana Hechtman Ayers

The Autobiography of Rain

©2024 by Lana Hechtman Ayers

Fernwood Press
Newberg, Oregon
www.fernwoodpress.com

All rights reserved. No part may be reproduced
for any commercial purpose by any method without
permission in writing from the copyright holder.

Printed in the United States of America

Cover and page design: Mareesa Fawver Moss
Font used in book: Mrs Eaves OT
Cover art: *Reunion*, by Andrea Kowch, acrylic on canvas, 36" x 36".
 Used with permission of the artist. https://rjdgallery.com/
Author photo: Andrew Ayers

ISBN 978-1-59498-138-8

in memory of Patricia Fargnoli
1937–2021

&

for all my beloveds—
especially those who fled this earth
way too soon—
you have a permanent home in my heart

As the rain falls
so does
 your love

bathe every
 open
object of the world—

 —William Carlos Williams

Let the rain kiss you
Let the rain beat upon your head with silver liquid drops
Let the rain sing you a lullaby

 —Langston Hughes

Contents

Immovable Clouds .. 13
 Nineteen Things No One Knows about Me
 (And One They Do) .. 14
 To the Art Teacher ... 16
 Wonder .. 18
 Immovable Clouds ... 19
 Elegy for Tenderness .. 20
 Window in Late January 21
 After you hung up on me, 22
 Grief Rhymes with Yellow 23
 "In the Distance People Are
 Making Even More Distance" 25
 Landscape in Dresses ... 27
 The Red Suitcase ... 29
 Dispelling the Mystery .. 30
 Thirteen Ways of Looking at
 the White Moth at My Window 31
 Imagine ... 34
 The Starry Night .. 36

 became sand　became ocean　became sky 37
 Shivering ... 38
 Every Hour .. 39
 Pyramids ... 42

Endless Rain ... 45
 Another Coronavirus Spring 46
 What the Sheltering Do .. 48
 no one said it wouldn't be hard 50
 Howe Farm Dog Park, December 51
 If I Carry My Mother ... 53
 Let's Play the Game .. 55
 Strong Verbs ... 56
 On the Nature of Grief .. 58
 Twenty Twenty .. 59
 Ode to My Steller's Jay ... 61
 The Shovel .. 63
 For Rainy Day, My Greyhound 64
 Need to Know .. 65
 Psalm ... 67
 The Well of Grief ... 68
 Abyss After Tea .. 69
 No Matter What ... 70
 Anti-Ode to Chicory Root Beverage 71
 Lazy Ode to My Husband of
 Thirty-Some-Odd Years 73
 Love Poem with Soup .. 75
 House Hunting ... 76

Rain Glow ... 79
 "Poetry reveals there is no empty space" 80
 Second Light ... 81
 What Do I Really Know About Anything? 83
 Artist Studio, Condemned 85
 Reasons to Live .. 86
 Thunder ... 88
 Caught as I Am in Time ... 89

broken umbrella	91
Of the Many Things I Was Taught Not to Do	93
How This Poet Thinks	94
Opera	95
The Joy of Words	97
Why I Write	99
Wings of Desire	101
Reunion	102
No Jars: A Life Story	103
Love Is the Key to a Luscious Apple Pie	104
A Blue True Dream	106
The Universe Is Made of Space	107
Not the End of Poetry	108
Creed	109
River Light	111
Things You Will Only Learn About Me When It's Too Late	112
Acknowledgments	115
Gratitude	119
About the Author	123
Title Index	125
First Line Index	129

Immovable Clouds

Dreamed some rain so I could sleep.
—Li-Young Lee

I don't consider myself a pessimist.
I think of a pessimist as someone who is waiting for it to rain.
And I feel soaked to the skin.
—Leonard Cohen

Nineteen Things No One Knows about Me (And One They Do)

I once had a brother who was a distant planet. Clear winter nights I can almost spot his nebula.

I was born dark. Things progressed from there.

My favorite color is swirl. Think van Gogh's *The Starry Night*.

My favorite bird is a crow but only when there is snow on the ground. Otherwise, my favorite bird is an astronaut.

Hills cloaked in fog is my best outfit.

My real mother is the moon—a cold stone barren of its own glow.

My real father was *Good Humor*, which explains my obsession with ice cream.

I have been mistaken for the help, but I've never worked that hard.

Salt is my favorite vegetable.

If I could be anything I want when I grow up I would be a pizza. Everyone loves pizza.

Once I tripped and had to crawl back home. My knees bled in the pattern of rose petals.

Twice I made the same hasty mistake. It cost me my sanity and a few subway tokens.

Three times was not a charm for me.

There are days I can't face. Sometimes weeks. Years.

The mirror me glares.

My name used to be synonymous with sorrow so I changed it to be synonymous with wool.

Whenever I see the sea my eyes water. Whenever I smell creamed spinach my mouth waters.

A man once told me I was beautiful. He also said, "God is a blowfish."

The rain is my best friend. She knows how to keep a secret and wash away the evidence.

The answer to every question I ever asked is *poetry*.

To the Art Teacher

You ask me to draw the breeze,
paint laughter,
sketch ambition.

You might as well ask me to capture time
with a butterfly net,
trap it in a mayonnaise jar.

I don't think in brushstrokes.
When I sleep, my hands are not unconsciously
shaping *death* from terracotta clay.

All I know are words.
I can tell you what yellow tastes like in soup,
the way red smells in the morning,

how blue feels against your skin.
I can rhyme the song of green.
I write the word *apple*

and you begin to wonder,
red or golden.
You picture the smooth ball of it

in your right hand,
roll the imagined apple around in your mouth,
crisping it between your front teeth.

This is how far you can go with words,
saying them, letting them fly around
inside your chest like bees

searching for flowers to make honey.
Is there a way to pollinate with paint,
can I take this white page,

apply colors, give you what you ask,
this dream with no words
and teeth of rain?

Wonder

Sky above
never leaves us,
never abandons us,
though it wears
inscrutable masks—
blues, grays, whites,
kaleidoscopes of dusk and dawn,
black sails of night,
all those stars tiptoeing around
and the floating moon
like a brooch I coveted
my grandma used to wear
on Sabbath days,
crystals that scatter-danced
waxing and waning crescents
of golden light all over
the synagogue,
proof of glory.
Such arrogance
I breathe the sky,
exhale nothing
save devotion.

Immovable Clouds

Outside, snow falls like a dream
of snow falling,
coastal weather inscrutable
as my black cat curled
beside the woodstove.

Girls in sweeping hoop skirts
twirl vivid oilpaper umbrellas,
stroll the April parade—
Japanese lanterns aglow
against slow, gray sky.

One ruby Fuji apple dropped
by an onlooker rolls in the gutter—
a spark shorn of its wick.
Halts at a storm drain.
No one dashes to reclaim it.

It's late afternoon
in the twenty-first century.
Silence is an attitude of shadow.
I turn from the drafty window,
my green tea still steaming.

Clouds swirl within
the bone-white cup,
whirling eddies,
snow drifts in pale spring light.
My life is far from over.

Elegy for Tenderness

Uncapturable in the past
as grasping at wind,

though now if I draw
my eyes up to breathe

sky, a graceful arc
of wings can stand in

for tenderness,
or encountering across

the grocery aisle
a stranger's smile.

On a misty eve,
the waning moon,

butterfly pinned
to celestial velvet,

sighs with me.
The world's crowded

some places, empty
others, all of us alone

in our own skins.
Any lit wick

that brightens without
burn, suffices.

Window in Late January

Snow today in this place
where it doesn't often snow.
Wet flakes blow sideways,
leaves on the salal flipping
like pages in some urgent book
writ with forgotten wisdom,
and the far-off fir and cedar
bristle their branches
wistfully, as if hung with the wet
laundry of soldiers returned home
from a long war, that like all wars,
cannot be won.
A dishwater sky mutes
sun's rays to gray, the hills
leading to the pass forested
in haze, drained of green.
The beach path's untrodden.
The sea crests cold foam
for no one—not man, nor hound,
nor soaring gull, nor majestic eagle.
Though a steady bluster, the wind
musters nothing but silence.
The plodding sound of melt
drip, drip, drips
from the askew rusted rain gutter
outside my purview.
Perhaps, I have all my life been
too much in love with sadness.

After you hung up on me,

I gave the moon my cold shoulder, trembling it was,
bared that spring night I waited in shadows.

Outlines of maple leaves lifted in the breeze
like a swarm of bats.

Air scented sweet with jasmine blooming from forced pots.
I wish I had something to do with my lips, even a cigarette,

though I failed at nicotine many times.
And wouldn't it be a perfect metaphor to blow smoke rings

around your absence?
I refused to go inside because if you ever did arrive,

I wanted you to see me in my beautiful new red dress,
backless and bold,

the tears in my eyes nothing more than stars.

Grief Rhymes with Yellow

so green is the leaf
clinging steadfast
to its branch
it defies classification
even by the wind
that wishes only
to call it *sail*

I have known wasps rail
and sting
merely because
I happened across
their flight paths

the sea does not cease
for me or anyone—
immortal heart

I can't breathe
under water
can't stay any bullet
in its chamber

a sane sky defines itself
by bird or flock
unseen moon
or stars hidden
in the clouds' dark hair

fear is like swallowing
one's own saliva
which cannot be
avoided

mud is the dream
of water

fish never argue
with streams

who says *yes* with their eyes
says *everyone*

Beethoven composed
even after he went deaf
the music in his head
like the soul's bells
which cannot be un-rung

no is the tongue's way
through doubt

the sight of a sad dog
closes my throat

hope is the thing with thorns
that pricks your thumbs
the trick is to remain numb

if it is wrong to miss you
pass me some strong perfume

the room is bare
of your hat

I half forget there will be an *after*
after this

before was when kiss
was relief

how if I were painting grief
I would lean on yellow

"In the Distance People Are Making Even More Distance"
—Tom Hunley

Years ago, I volunteered weekend
overnights at the suicide hotline.
Every time the phone rang,
which it did at regular intervals,
especially Saturday,
my cheeks flushed with heat.

I answered, asked for a name,
said *how can I help?* and little else.
Then I listened,
more to the sounds between words,
than the words themselves,
all sorrows being equal.

Some callers breathed rapidly,
as if caught mid-run.
Others sighed deeply,
long exhalations,
as if internal drought
raised a cloud of dust.

Many callers cried.
Siren wails.
Hiccupping sobs.
Moaning punctuated by
a hysterical note of laughter.

Each sound a unique
song of pain.
Whatever the melody or key,
I attempted to harmonize
my breath with theirs.

More than any shallow syllables
of words, I believe this is
what saved them—
for an hour, or an evening,
or maybe a lifetime.

Testimony rising from my chest,
the best way to say
I'm in this with you,
your ready, steady twin.

Suicidal ideation is a lonely
night train whistle, isn't it?
Pining for that unattainable
distance not only from the world,
but from oneself.

I've wanted to board
that locomotive so many times,
imagined landscapes
rolling by, reflections
in the night-quiet windows—
my face,
my face alone.

Now, I watch the days
move through shadow
to light to shadow.
Nights, I lie awake trapped
in the middle distance
and ponder how deftly
the moon negotiates
its closeness to our dreams.

Landscape in Dresses

Glimpses reflected in mirrors
 part sky part shaken branches
never your eyes
 only the moment of motion departure
Where is it you go
 when I lose sight of you in fog?
I'm certain I've seen you in dreams
 that smell of burnt toast
On rainy days your laughter chimes
 raindrops against roof gutter
When I taste lemon
 I believe I am closer
to knowing you
 tart craveable

How does desire dress?
 In fir needles
maple leaves
 the unlined forehead of youth
I wet my lips imagining you will ride in
 on high tide aback an orca
No I don't
 I hope the inexpressible returns
like the Steller's jay
 to the handrail of my deck stairs
every morning around ten
 my fear
inevitable as splinters

What I believe I want is soft
 what you are is silver glass
shards gleaming
 for the warmth of my blood

Words never pass between us
 so there can be no lies
My fingertips force the pen
 over parallel lines
outside the margins
 if anywhere that's where
love exists
 scribbled scratched out indecipherable

When I look into the reflection of my eyes
 all there is *is* shaded lake surface
murk brown a single pebble radiating out ripples
 siren call for help

The Red Suitcase

We were going to live forever,
yellow as the galaxy of your favorite

sweater. Chickadees chirped notes
of glee while we seasoned romantic

plans with crumbly dried leaves.
We took to the pages of books,

creamy paper smooth beneath our
curious fingers, dark texts puddled

in flashlight. I wanted to plant a cubic
garden but neither of us preferred corners.

One April, a man arrived who pretended
answers from the sky, his eyes huge

caverns. Afterward, you wandered
off, never dropped a line. I declined

offers of streets laden with ladybugs.
I dreamed my way through treehouse

after treehouse in search of a closet
where rain never fell. It was all in vain.

Whenever I woke, cows were cloaked
in dew, a gray haze over ridged pastures.

Alone most days, I followed the gloaming
curves of clouds, backstroked late nights

in toffee moonglow. It has taken me years
to discover this forest composed of broken

pencils, every shadow a word erased from
my heart. Your name is not one of them.

Dispelling the Mystery

after Tony Hoagland

Late morning throws shadows at odd angles.

The sky wants to be optimistic for you but sometimes can't hold its cloud water.

The serrated wings of birds slice through the hours.

There is a feeling in the air of impatience, as if the seam of the horizon is about to tear.

There is an audible rhythm to nostalgia discernible only by someone who is willing to close her eyes and attune to her internal blood river.

Some futures will never materialize in your remaining days—true zero-gravity chairs, stepping back in time to have tea with Emily Dickinson, reverse aging.

This life that rushes like a hurricane blows it all down, compacts everything until it is difficult to breathe.

Right now you sit at your desk staring out the window at the same planet you've known your whole life, from a different street than the one you were born on, calmer because you finally realize whatever time you have remaining is as the rain, it falls, it all dries up, then starts over again. There is nothing to take back.

Thirteen Ways of Looking at
the White Moth at My Window

I

The white moth was
a cloud fluttering
in the cloudless blue sky.

II

It was a trick of sheltered mind,
my thinking the white moth
trapped on the inside.

III

The white moth bobbed along in the spring breeze,
a tiny blossom loosed of its stem.

IV

An onion skin and a garlic peel
are one.
An onion skin and a garlic peel and a white moth's
wings are one.

V

I do not know which to prefer,
the beauty of the ambiguity,
or the beauty of allusions.
The swooshing of the white moth's wings
or just after.

VI

Hail coated the wide window
into frosted glass.
The shadow of the white moth
paced it, up and down.
The ambience
traced in shadow
an indecipherable verse.

VII

O tourists of Cape Meares,
why do you imagine gray whales?
Do you not see how the white moth
magnificently hovers above the heads
of the children with you on the beach?

VIII

I know quiet melodies
and anguished, irrefutable notes;
but I know, too,
that the white moth is crucial
to what I know.

IX

When the white moth flew out of sight,
it erased the boundary
of my narrowed vision.

X

At the sight of the white moth
soaring in haloed twilight,
any songstress
would hold her breath.

XI

A man flew to Massachusetts
in a jet plane.
Once, overtaken by dread,
he hallucinated
the exhaust from the engines
as white moths.

XII

The moon is rising.
The white moth must be flying.

XIII

It was morning all night.
It was raining
and it was going to rain.
The white moth flitted
around the porch light.

Imagine

John Lennon speaking softly

the way one might be
to persuade a gunman
not to shoot

whispering words
you cannot make out
in your dream of
Lennon cross-legged
on the immaculate white sofa
in his famous Dakota penthouse

his round eyeglasses
reflecting infinities
in the glass coffee table

Lennon cooing syllables sweet as
corn feed to the crowd of
Columbidae in his living room
yes rock pigeons everywhere
their smooth green heads
their black moon eyes

iridescent necks nodding
as they prance toward Lennon
such is his anima connection
to these much-maligned
sacred beings

pink feet lifting in rhythmic dance
a trance a prayer a karmic call
for all creatures to let be

while outside the thrown-open
balcony doors the Hudson River's
waters shiver

and just imagine seven stories
down below on the West 72nd
Manhattan sidewalk

peace enters a troubled soul

The Starry Night

At MoMA in New York at eighteen,
I discovered Vincent van Gogh's *The Starry Night*.
I stood so close after the security guard walked by,
I smelled the century between us,
heard the cry of wet paint long since dried.
I had no context for the tortured life of a man a culture
and religion apart.
Had no knowledge of the asylum
from whence the scene arose.
Yet in that moment, I felt van Gogh as soul twin,
one who understood the world is never still,
impending darkness and the cacophony of exploding light
engaged in a fight for dominion.
His cypress tree like the sword of doctrine piercing
the fabric of time.
I have never been at home anywhere
but in that painting,
or else in the rain where drops become
my shroud, my sanctuary, song without need of lyrics.

Whoever knows what they were born for is truly fortunate.
I scribble in notebook after notebook,
as if to clear the way by making it muddier.
I want to know it matters, any of it,
Earth, humanity, a few humans in particular,
perhaps even myself.

Alone in my apartment, looking out,
the stars like drops of rain
glistening on the windowpanes of the universe,
I've come to believe by way of pain
and a singular painting
that if love is the answer,
no question matters more than any other.

became sand became ocean became sky
after "Coda" by Patricia Fargnoli

At the cabin in Pemaquid, Maine
 we were as fluid as mist that socked in
 the mornings of our retreat days
soft and surreal
 so that our words sighed like the ocean outside
 lighthouse a quick-step stroll away

our poems glided onto pages Möbius as seagulls—
 we colored in white lines with blue glass bowls
 a tambourine a teapot giant beguiling isles

meanwhile the world far away from our mystical
 poets' globe seethed with the usual meanness—
 injustice war oozing angers

that transform anything
 even furniture into weapons
 the rocking chair smashed against a wall

all we knew was tall beach grass shifting dunes
 the calls of owls high in the pines at night
 wind-scattered stars

the last day we went our separate ways
 back to our opposing coasts
 clipped cities

had I known that it would be the last time
 I'd ever see you—
 no tears no parting words

only breath on one another's cheeks
 our oblique poems of being
 a hug so tight I'd still be holding you now

Shivering

for Patricia Fargnoli

I rise in the still shadowy house filled
with the snores of my sweet, old dog
lying on the wooden floor, legs raised
in air, splayed like covers
of an open hardbound book.

I move to the living room
where picture windows display
a canvas of a sky dimpled
with stars, a lemon slice moon
dipping into dark sea.

My life is an upturned vase, glowing
with golden fracture, a tarnished
saxophone crooning its gloomy melody,
floors strewn with crumpled pages,
words all too elusive.

What I crave is a thunderous
cup of coffee, a stroll through
breeze-waving evergreens,
a violet suture to repair the rent
sweater my heart is without you.

Every Hour

Dawn began with the sight
of red lights
flashing on numerous trucks
crowded by the beach entrance,
some emergency that brought out
firemen and state police,
sheriff and ambulance.

And now, as daylight moves
toward dusk,
a doe, ears pitched upright,
perhaps by the clacking
of my old keyboard,
pauses its chewing
of the native salal,
stares into my open window
with eyes that seem to see
right through me
and my fallow pursuit of words.

How swiftly the world shifts
from safety to siren,
every hour some new threat
opens like bud, ripens like berry,
and all the while crows frolic
in the broken-glass-strewn grass,
sparrows flitter across
live electrical wires,
and remain largely unharmed.

We humans come into this life
entirely reliant
on others for survival,
but shortly thereafter

come to understand
death is the inevitable
through-line
for everyone,
and only luck and bluster
get us most of the way there intact.

It is a fact that our home planet
spins on an axis,
though we seem fixed and upright
as the sky wheels its daystar
and night-moon through the pane
of ever-changing horizon.
What lies ahead
is more of the same,
and nothing we imagine.

This morning's emergency,
our next-door neighbor tells me,
when I am out in the evening
walking with my two dogs,
was a surfer taken under the waves
by riptide, drowning,
fighting for his life,
as one after another
family member rushed in to help,
succumbing to the omnipotent
seawater themselves.
"But one stranger dove in and rose
again, so everyone left breathing," he said.
"Good news in the end."

And that seems a fitting summary
for what we all want—
breathing in every hour
until the good news
of our demise arrives,
and hopefully, it is good news—
because we lived with joy
despite all the pain
that came calling
once and again,
but also vanished for stretches,
and we watched with awe
the inquisitive deer
watching us,
munching idly on leaves,
and we dipped a toe
or two or a few
into the almighty ocean,
and we told ourselves
over and over
the very stories
we wanted to hear.

Pyramids

after Stephen Dobyns

Irritable in my office chair over a mistake that's too late to unsend, that didn't say what I truly meant, early on a late-spring day, I'm staring out through my salt-stained window at Pyramid Rock, the sea stack that rises from the Pacific Ocean at Cape Meares beach, Oregon, our daystar glinting on restless wave crests, all forward momentum, and my mind meanders to Stephen Hawking and how he so wanted to believe in backward time travel, he held a party for time travelers, the invitations to be sent after the party concluded. No one showed up.

It is hopeless to conceive of changing one's past, and yet I continue to obsess. What if the sea were a portal, each sunlit row of incessant surf a tunnel to somewhere else, some other when? What then? Which one of my many missteps could I retake to remake the current me?

Tourists stroll the beach in twos or threes, some with dogs unleashed, unaware of me, up above at my desk. To them, they are unseen. The sand beneath their feet is ever shifting. Does the Earth ever tire of all this change? And yet, the past is cast in history, never to be reshaped. The sea swells glisten so whitely. The beachgoers travel lightly. They are on a brief break from the everyday, from the sameness, listening to the wave's steady roar. I remain in my office chair, wishing to be anywhere else. No—any *when*.

Hawking knew there was no way to prove time travel to the future, but considered the case closed with travel to the past. I don't know, but hope there is a chance I've already danced with probability, imagine the billions of alternate lives I could be living right now—the me who said *no* to that boy who flipped my virginity like a bottle cap; the me who insisted on going to college for a poetry degree instead of falling back on the safety

of mathematics; the me who said *yes* to teaching, to reaching out to others, instead of hiding behind actuarial tables; the me who wasn't a failure because she kept trying, kept applying herself even when it appeared futile.

Hawking said *life would be tragic if it weren't funny*. The sun is still glaring down on everyone, everything. Hawking was an exceptional human for exposing possibility everywhere, expanding our cosmos of knowledge even as he was confined to a wheelchair in a useless body, his mind the kind of fusion he hoped would power Earth's future. Hawking had only the use of a robotic voice to communicate the most far-reaching theories. And I sit here at my desk querying the ways I could have made my small life better by changing the past, somehow.

Now is all any of us ever have. Though those ocean waves out there seem to break forever, whitecaps flashing like a billion brilliant tossed coins spinning on their edges. Every decision I've ever made, no more than a coin toss. Loss is what we make of it.

Hawking said *people won't have time for you if you are always angry or complaining*. So maybe this is a poem explaining how I sit at my desk each day trying to say something not just hard to say, but impossible to even begin. Because that singular idea has not formed itself into language yet. Just buzzy neurotransmitters and synaptic gaps that can't be leapt.

The tourists have left, perhaps to get a bite to eat after a stellar morning at the beach. I reach my fingers to each letter of this keyboard missive to let you know, as clearly as I can, I'm here, and I understand this is a miracle. That any number of odds in the past could have made it otherwise—the proverbial bus stepped in front of, that death-head of steel in so many theories, or the parents who never met, never conceived me,

or perhaps, even the big bang that created this entire universe having been a mere poof. Hawking died without proof of time travel. The ocean outside my office has seen every eon, and unless we destroy the planet, will see many more.

And still, something in me desires to explore the prospect of becoming Hawking's first time traveler, unraveling the physics before his eyes so that I arrive back in 2009 in front of the welcome banner he made for visitors from the future. I will take his hand into mine, say to him, *What a fine party you're throwing*—elated to be the guest of honor.

I reach for my champagne flute from the elegant pyramid stack of glasses, toast his delightful hosting. Day into night, Hawking and I talk of all things right with the world—the glorious seas, the countless varieties of trees, the radiant stars, their light truly time traveling from the distant past, through vast fathoms of time to inspire us both, rarefied and wish-upon worthy.

Endless Rain

*... my poetry was born
between the hill and the river,
it took its voice from the rain,
and like the timber,
it steeped itself in the forests.*
—Pablo Neruda

I loved you like rain.
—Cecilia Woloch

Another Coronavirus Spring
after Molly Ellen Pearson

As soon as I open the window,
the sky climbs in dragging her
bridal train of clouds. I only
wanted to air out the pandemic
stale, instead there are kites
swooping over the kitchen sink
and hummingbirds buzzing
around the lampshade. Yesterday,
I thought my hand resembled
a piece of toast and I'm gluten
intolerant. My poor elderly cat
battles dust mice under the couch.
I wonder if I'll ever sleep on
a raft of starlight instead of
underground and whether my dog
dreams in color or stereo. Days
become inscrutable as kumquats
and I scribe lines of used dental floss
across the pages of my notebook.
Is it really spring or is the mud
pretending celebrity? Daffodils
solve the square root of yellow.
I zigzag from cupboard to closet
seeking a way to complete
the circuit of knowledge. My life
is forty paces, end to end. Coffee
aroma fills me with longing.
The computer screen flutters
with paper dolls and lately I have
been transfixed looking in
mirrors, gobsmacked gazing at
lettuce awaiting shredding

on the cutting board. What does
it take to make proper reparations
for being human? Some nights
the moon shouts in translated sun.
Some nights the moon is mute
and I buy raffle tickets for the rain.
I'm tired of shallow breathing, this
everlasting Gordian knot of grief.

What the Sheltering Do

*after Marie Howe and for my brother Alan,
Red Cross EMT at the World Trade Center, who died of
a 9/11-related illness*

Brother, my freezer—arctic—
resembles the old snow forts we built in childhood,
and hot water does no good, making a flood and more ice.
There is no repairman to call in this time of sheltering in
place. This isn't the everyday we dreamed of.

For weeks now, staring at faces on screens—TV, phone,
laptop—I'm recalling being seated across from you at
the coffee shop, your hair gleaming in a shaft of sun,
your laughter cutting through the din of conversation and
piped-in tunes. I stay home now to make my own brew.
This is what those of us who want to live do.

We cleave in place,
cleave from one another to flatten the curve.
This is how the ordinary serve.
I didn't want you to leave that fateful day—or ever.

It's nearly spring here, bright with bloom—
pink blossoms and green leaves erasing all memory
of winter's blahs and grays but winter's cold remains.
My heater believes the calendar that proclaims spring
and refuses to come on.
I shiver wearing several sweaters, no repairman to call.

Turnips are all I eat for the fifth night this week
because the market is out of everything,
and facial tissues are what I use as toilet paper.
This is what those of us who want to live do.

You had no choice in being here or not.
Terrorist disease took you from us.
This is not the everyday life we dreamed of.

True, mine are ordinary griefs—
broken appliances, whatever the store
is out of each time—
but as my washing machine refuses to spin,
I'm gripped with a sadness so deep for what might have been
if you hadn't left us before this global pandemic,
you who manned the front lines on 9/11 saving lives.

Despite the new great losses your heart would endure,
you'd rescue so many more.
You, brother, would as surely be a hero now as then.
I honor you, I will always honor you.

no one said it wouldn't be hard
after Maya Stein

It is always hard. The pickle jar that's hermetically sealed,
your grandma dying on Christmas,
the junior high bully who set his sights on you and never
let go, leaving the pan to burn on the stove till the house
smells molten as a smithy shop, your car breaking down
on the way to the interview for the first job you ever really
wanted. And here's the thing—
it never gets easier. Never.
You lock yourself out of the house in a freak snowstorm,
the repairman calls to say the engine can't be fixed,
a lover leaves you for your best friend,
there's a mysterious spot on your X-ray
that requires more extensive testing.
Still, a warm hearth fire is waiting somewhere quiet,
and a good book if you're willing to open it,
even a deal on the Subaru you thought
you could never afford,
and a friend who texts to say she's baked too many chocolate
chip cookies, do you want some?
Too bad there isn't a scale anywhere that balances—Lady
Justice forever blindfolded and brandishing a sword.
Thank goodness there are sunsets, eggs over easy
sprinkled with Himalayan sea salt,
the sudden breeze that sends a shower
of honeysuckle scent across your path,
an old maple tree on the corner that stands
sentry in every season.
And then rains come, dousing the ground,
soaking your skin, cleansing you of the grit, too,
at least for a while.

Howe Farm Dog Park, December

At the click of leash release,
the big dog runs off,
disappears into the woods,
the smaller dog stays close by
my bootheels
sniffing at the smorgasbord
of dog park smells.

All I can identify
is a scent of damp,
something like wet wool
tinged with the tang
of pine smoke.

It's so bitter cold a day,
the mud is solid,
crunches underfoot and the late
afternoon air has a gray/blue
cast that makes me want
to forget context, forget words.

Little dog and I head toward the path
of spindly Douglas fir,
bared alder, cedars hung with rust.

She runs in front of me on the trail,
takes the lead by a yard,
her tail become a quarter-time
metronome as she surely selects
an acceptable clutch of brown
leaves to piddle on,
then bounces ahead.

Dogs are satisfied
with earth—
its animal markings,
satisfied to deposit
fragrant evidence of their own
existence,
however transient.

This year is closing down.
What I lost I will
never regain.

Big dog comes suddenly
bounding toward us,
panting bog breath,
all tongue and canine smile.

This is a good life,
she seems to be saying
in dog language,
a good life,
even when it's frozen
and overcast,
even when the forecast is
more of the same.

If I Carry My Mother

after Marjorie Saiser

I hope it is little more
than her brown eyes,
unremarkable
as beans,
that scowl at me
from the mirror,
or these bunioned feet
wide as pontoon boats
and clumsy
on ice or dry land.
Let her never materialize,
never spill
from my satchel of DNA,
with all her bigotry,
vengeful, venom-driven
outbursts, curses,
her bitter woe-is-me
personality.
Or if she must
bust through
my inner armor against
inherited ugliness,
let it only be my mother
from her last years,
steeped in dementia,
when she believed
she carried
a talking dog
named Patchy
on her shoulder,
who loved to sip coffee
right out of her cup

and paw everyone
high fives.
Only when she'd lost
her mind
did my mother become
a facsimile
of someone kind,
and for such a brief,
brief time.
But, oh, how I loved
that dog.

Let's Play the Game

after the song "Au Revoir" by OneRepublic

My father's eyes gray haze,
cheeks concave,
sore-covered lips, withered limbs,
hospital-visitor rules
dismissed,

eight of us huddle
close in
around him,
for what we don't know
are his last words—

Anyone bring a ball and a bat,
he rasps,
we've got enough here for a team?

Strong Verbs

in memory of Patricia Fargnoli

All through the night she left us, the stars
failed to take notice, went on twinkling.
I lay in the lawn chair in the yard
wondering if life after life is possible,
whether the existence of a soul
is just a fairy tale we tell ourselves
to avoid despair.

The moon pushed across the arc of horizon
softer than a shout, lonely, misunderstood.
What if death is a kind of homelessness
away from one's body,
and what comes after death
is dampness, cold, hunger, and fear?

I haven't forgotten what it felt like
to love her, how my breath flowed deeper
into my solar plexus when she spoke
about poetry, said *poetry pounds*
it's invisible hammer, erects more
visible beauty in the world,
nails gratitude into our hearts.

Sometimes I want to run away
from my life without her in it.
Sometimes I want to testify
on behalf of all her poems,
recite "Roofmen" until
it calcifies into your bones.

The stars emit their remarkable
shine over us freely,
but for a poet to bestow such radiance
requires sacrifice,
requires allowing the world
to pierce with arrows
so that the light of sorrow
shimmers through every wound.

On the Nature of Grief

after Patricia Fargnoli

It is not the bufflehead floating on the pond that dives
headfirst into the stillness. It does not quiver

like the squirrel along the fence line, worrying away at some
nut, nor is it the jittery rabbit chased into the hedges by
unseen hounds.

It permeates the landscape of the mind, wish stars and
sunrises, the ever-shifting phases of moon, and falls like rain
cold, soaking, drenching. It also thunders.

Take notice how fog clings to the mountaintop. Take notice
how air swirls into gale force in a single pulse of your heart.
This is grief.

It cares not a whit for the work you need to accomplish—
grief is lights out, power grid fried, silence that strangles
even as the moon waxes.

It is not inanimate. Not a boulder rolled uphill or hourglass
of swiftly emptying sand. Not even frost heaves in asphalt or
an algae-stained empty swimming pool. But it might be dust.
Ordinary dust.

It is the amorphous sheen of shadow as clouds sheet across
the horizon obliterating the cornflower blue of day.

It is red sirens of night, cawing startle of crows
scattering from pine boughs, swarm of hornets seeking
heat of skin to sting.

Massless, yet heavy as uranium, we bear our griefs
as pinned wings, ever grounded from flight.

Twenty Twenty

This was the year breath became death.

The year the grandparents and great-grandparents left us by the thousands, taking their wisdom with them into the great oxygen mask of the heavens.

This was the year we covered our mouths and smiled with our eyes if we were able to smile at all.

This year handshakes became passé and hugs a mass hallucination we once had.

This was the year we sorted ourselves into a society of screens. The year we finally acknowledged how crucial delivery drivers and supermarket stock clerks are. First responders heroes now more than ever.

This was the year we remembered how to bake bread, learned how to garden.

The year we discovered different species of trees possess distinctive aromas.

This was the year we binge-watched and wore out pajamas.

The year we took our pens and our notebooks seriously.

The year we were speechless.

This was the year we embraced the zen of handwashing, observed all the delicate shadows the moon tats across night lawns.

This was the year we canceled weddings, Christmas, died without anyone familiar by our sides.

But this was also the year we took unscheduled strolls in the forest alone, attended the sea's susurrus lectures, hiked higher than ever before.

The year we feared air and loved air and drove less, thus clearing the air. This was the year we did more fretting, more regretting.

We vowed to vote and kept our promises to ourselves and others.

This was the year we stood up to racial injustice in the myriad ways we could—in the streets, on Facebook, writing to our senators, calling for action against racist police, donating to causes, celebrating artists of color, holding our white tongues so the underrepresented could be heard, acknowledged, admired.

This was the year we used our phones to make actual calls, voice to voice, not just for texts and emojis.

The year we cried and shook our heads and wrung our hands at the headlines.

This was the year we lost sleep, lost heart, found hope entails action.

This is the year we said *I love you* over and over.
Sometimes to the person on the other side of the glass.
Sometimes to songbirds.
Sometimes to ourselves.

The year we said *I love you* to our fragile Earth.
Said *I love you, I love you* to the universe, and I love my humble place in it, no matter what.

Ode to My Steller's Jay

I call you mine,
but no one can possess
a creature so prepossessing,
cerulean slough of tail feathers,
azure arabesques of wing feathers,
wild emo, that sleek punk column of black
razoring atop your head,
iridescent onyx nape, satin sable cape.

For months, you come to me at 10 a.m. like an aubade
of luck, the best idea I hadn't yet had.
Perching on the deck rail outside my office window,
you tilt your head, looking in at me, as if we
are in this together, this try for beauty,
you and your ever effortless startling grace,
me troubling the clean pages of a notebook to express
with messy black and blue inks what you do naturally—
brushstroke the landscape of life with brightness,
even in this Pacific Northwest cavalcade of gray, gray
days and endless rain, offer affirmation to unfix the eye
so focused on despair.

When you tire of looking at me, you leap away,
a single squawk into whatever your day's adventures,
smear into atmosphere Aegean mermaid blur,
supernatural being one only imagines can truly exist.

For months and months, it's you and me,
morning trysts where I'm held as gleam
in the obsidian beads of your eyes,
making me believe
I can craft something merely half
as glorious as you are.

One August morn, you fail to arrive,
nor the next, the next, and I pray
you're still alive, not radiant prey
of some alley cat or giggling eagle.
Months lope along without you, and in
my listless notebook, lines cross, lapis-less,
my being at a loss for alluring language.
I look up to the sky,
I look down toward the sea—
they can never be
blue enough.

The Shovel

The hole outside the sunroom
needed to be dug deep but
stone by stone, dirt refused the shovel.
Gravel gave way to cave-ins.
As if earth were declining
the offering to be placed within.
Not a rosebush, not a maple tree,
not a half dozen daffodil bulbs,
but one domestic cat,
body stiff with rigor mortis,
fur matted to homogeneous gray,
one swollen eye gone to cloud.

A cat in life called Federico Rodolpho.
A romantic name,
heavy mantle for a light cat,
sharp cheekbones,
pointy antenna ears,
who loved riding on shoulders like a parrot,
fetching toys like a retriever,
who had been with us a mere two years
before the specialist's failed intervention
into a mysterious disease.
Two short years of feline bliss,
a cat to be missed a lifetime afterward.

In the end, the shovel triumphed
as it always does,
death's earthbound accomplice.

For Rainy Day, My Greyhound

May 4, 2008–October 14, 2021

Is it a trick of shadow
or memory's insistence
that I spy you
out of the corner of my eye?

Sleek as a deer, majestic as a lion.
The color of shadow yourself,
except for your smile,
bright as looking into the sun too long,
an afterimage burned onto my heart.
Tip of your tongue hanging out
like a little pink heart itself.

You're shaking off sleep,
perhaps a dream of running,
to prance toward your water fountain
and quench what must be
death's eternal thirst.

You can't be here, of course,
but even after my eyes adjust
to your absence,
the jingle of unseeable collar tags,
rings and rings and rings
like a bell calling me to morning prayer.

Need to Know

 I can hardly imagine it,
sunrise in a violet sky
that scientists tell us
is the truer hue of light than blue,
our human eyes not properly
attuned to see.
And moonlight is greener.

We're all more empty space
than solid, with our elements
entwined in twirling orbits,
particles a cosmos apart
on the atomic scale.

 Does that mean I could walk
through walls if the clear bonds
of my generous frame flutter
at just the precise frequency,
walls being mostly empty
space as well?

It's an odd time to be human.
We understand so little.

 How is it chemists can assemble
all the ingredients for a cow
in the lab but not know how to
breathe life into it,
make it get up and moo?

God is not a new idea and some
of the greatest scientists, Einstein
included, believed in a mastermind
at work in our universe.

 And there may be infinite universes
outside ours, as one theory suggests,
each one a soap bubble in a sink full of suds.
Still, I want to know who or what
invented the sink, the brand of soap.

In my life today, it matters little
if the sky I wake to looks violet
or blue or even gray and
raining down rivers of drops.

 Yet, truth feels to me as necessary
as breath and bread, water and rest.

I need to know if when I die, I'll see
rose quartz light, no matter
its true color, and after that,
whether I'll disperse into disjointed
particles,

 the way my dog's ashes
spread out on the wind today,
first like smoke,
then like beads of shadow,
and then, in the end,
like nothing at all.

Psalm

I only discovered the web once I was home, washing my hands, looked into the mirror and saw its delicate lattice draping my dark hair like a white veil, as if I had just come from a church wedding, rather than a stroll in the forest, which is nature's cathedral, but I had profaned its sanctity, carelessly torn away some sacred spider's arduous spinning, perhaps even stolen her dinner, leaving her exhausted and hungry, so I lifted the fine silk from my head carefully, laid it on the sink counter where it hung deflated over the edge, where it hangs still months later, like a prayer book overturned, saved open to the page of the daily psalm that begs forgiveness.

The Well of Grief

after David Whyte

The orange klezmer music of sun
nowhere to be seen,
today's atmospheric fog white as worry,
though somewhere else the hazel-colored wrens
rest on the still-green boughs
and in the distant bluest seas
great orcas sing songs of long generations,
but here in my county of dread,
the refrigerated morgue truck pulls up
behind the hospital for the newly Covid dead
whose numbers exceed normal storage capacity.

Red as gore illuminated sirens
are the sorrow songs
of this too-long pandemic.

Summer nearly gone,
the elation of blooms has faded
to solemn hymns,
broken only by thunderous cracks of rifle strikes
from the forest in back of my house,
ominous as organ music at a horror show—
hunters eager for pre-autumn kills.

Stillness returns for the moment,
but not in my heart that beats
anticipatory grief like pebbles
cannoned into a dark well.

Abyss After Tea

after the photograph of Ann Lockley, 1938

We are all disappearing into history.

Some of us go swiftly, soundlessly,
a lobster roaming sea cavern depths.

Others zigzag, innocent as steam
in a storm, dissipating without a trace.

Perhaps you will soar away, raptor talons,
dragging whoever else you can snatch.

I think back to my European ancestors
showered with asphyxiating gas,
last moments all gasp.

My leaving will be a catastrophe
of regret only, a set of nesting baskets,
one emptiness filling another.

No Matter What

Do not be angry with the rain;
it simply does not know how to fall upwards.
—Vladimir Nabokov

I am the moon's dark side.
The shadow that falls over the lake
that fools fish to feed on nothing.

My only sparkle is the broken scatter
of window glass.
Don't ask how it came to shatter.

If you see me crying, imagine it is no more
than fog enveloping the hillside, that soft.

What you may have forgotten is that
I love like a moth drawn to a forty-watt bulb.

Call it ignorance or passion. Call it too much,
the consequences of caring,
like bathtub rings refusing to wash away.

Once I dreamt of being the horizon,
straight arrowed, profound demarcation
of distance and future.

Now my gait is sluglike.
See me ooze on my way to nowhere.

You may wonder why it all went wrong,
my life, but that's not the right question.

Ask me about the rain.
How to drink it in and in and in
and never drown.

Anti-Ode to Chicory Root Beverage

Bastard step-cousin of coffee thrice removed,
who but those preservationist Egyptians
could have cooked you up
for the body's morning fuel?
Hairy albino carrot reminding no one
of rainforests, mountaintops, Juan Valdez.

My doctor says I can't have the real thing
any longer, caffeinated or not, fifteen hundred
chemical compounds contained therein,
half of them toxic to my condition.

Enter you, who, granted, in your powder form
resembles an espresso grind of those honest
roasted beans I've had to wean myself off of.
But there all resemblance ends.

Your flavor tends toward treacle
with metallic aftertaste.
Worse still, the pasty scent you emit—
no heady aroma of smoky, earthy glory—
no, you smack of compost,
rotting.

Gazing into your foamy slurry,
some granules remaining always undissolved,
I almost believe you could be my one true
religion, my brain brew,
though a sniff or two, a sip inform otherwise.

Yet, now when I get up in the morning,
I look so forward to cupping you in my hands,
hot in the brown-glazed, handmade ceramic mug
from Cascade Pottery that makes me feel like
I'm safely hugging fire,
pleases the cavewoman in me.

Even though you're a liar and a tease,
muscle memory, the ritual stance
of imbibing your dark brew swallow
by swallow in the blight of morning light
satisfies tolerably enough to keep me
up on my feet until mocktail hour at least.

Lazy Ode to My Husband of Thirty-Some-Odd Years

no roses, I'm afraid
or bedroom antics that summon
firetrucks to our home
(leave those to N. Diaz—
see "Ode to the Beloved's Hips")

we require separate bookshelves
separate bathrooms
at all times

but there are a few notable items

the way settled floor joists bounce
beneath your lumbering footsteps
setting off tremors

your serious conversations
with our cats about
Fermat's Christmas Theorem
Euler's Calculus of Variations
(meows suffice)

spicy gluten-free blueberry waffles
and over-easy eggs you've perfected
for my Saturday-morning palette

perhaps a half dozen other things
I could conjure up if I stopped
to think which I don't
(you almost died—
)

let it always be this easy

effortless as humming
a beloved familiar tune
even though the lyrics are
lost to us

Love Poem with Soup

for Andy

The blender pulverizes
fresh-picked spinach as if
its leaves were not fragile
generating a green slurry

a blood-thick broth
and my husband measures in
curried red lentils
sticky black quinoa

olive-oil cured garlic
and iodine-rich salt
to create a soup that will
nourish me

for the duration
withstand weeks
of freezing
without suffering

ice burn
withstand reheating
in the nuclear gasp
of the microwave

yet taste
of a life
bred in fertile soil
under spring's violet rains

and through summer's
brickyard sun
our days in this garden
so brief

House Hunting

We're looking for something spacious
as the interior of a poem,
so roomy you can get lost in its images,
hallways that roam along
to unexpected turns of phrase.

We're hoping to find something close
to all the conveniences—
fresh air perfumed with meter,
trees that tousle their limbs
seductively in breezes,
hills curvaceous as villanelles.

We're searching for a place that fits
our personalities—a kitchen of clean
steam and courtesy, delectable soups
and sestinas bubbling on the stove,
a bath where unsullied truth
freely flows from all the taps,
a bedroom that masters
the art of moon phases and meteors.

We're seeking a home we can fill with
blankets, dog fur, cat fur, the enjambment
of too many books.
A home that will hold steady looks,
silly askance glances,
even a few cross words once in a while.

A home that weathers moods well,
the way streams wear every broken rock
down to pebble shine.

We don't mind winding avenues
of rhyme, and have no preference
about windows, so long as they're
always wide and wise.

We don't care for one-way stairs,
though being able to stare at a view
of empathy is essential.

We want a home in which light
is as bright as the scent of lavender,
a home where the sound of rain
on the roof is our hearts' sonnet
as our arms reach for one another
in the night.

And we want a home where the silence,
however rare, is always and ever holy.

Rain Glow

*I will die in Paris, on a rainy day,
on some day I can already remember.*
—César Vallejo

The rain, it turns out, has a hand in everything I love.
—Matthew Dickman

"Poetry reveals there is no empty space"
—*Hafiz*

Out of the void: dishes, dust, screens, fire fight, firefly glimpses, tipsy kisses, too little, too much, lingering rosemary, cups of coffee, bitterness of heartbreak, guitar chords from the basement, implicit threat, green rage, Stevie Wonder, Beethoven, Janis Joplin, the Kosciuszko Bridge, windows open wide, something unforgivable, traffic, too hot, too cold, weight squarely in my body, wooden spoon, stream, salt of grief, loneliness, barking dog, pearls, pencils, hand stirring the pot, books, wind, rain furrows, moonrise, alchemy, edgelessness, yawns. It was a Monday.

Second Light
for Ciel

Last night, after I turned on one lamp too many,
the breaker tripped and all the lights extinguished.
I noticed that even in the dark I could see
the shapes of things—
outline of the doorframe,
straight edge of the upper cabinet,
curve of the countertop,
person-like outline of my desk chair.

It was as if in the dark there was a second light,
a brightness within shadow that goes unnoticed.
So preoccupied are we with harsh illumination
we forget the world is not all duality—
not all good and bad, not all right or wrong,
not this or that,
but shades of meaning and profundity.

I walked to my chair
not tripping over the edge of the rug,
not bumping into the protruding washer/dryer
and sat in my seat breathing in
the dark, my heart a soft metronome.

I could make out the messy scatter
of white pages on the surface of the desk,
piles of books, the nested rectangles
of my laptop and its stand, its screen
darker than the air in the room.

And though I knew I couldn't read any of the pages,
I moved my palm over the surface of printouts
that emitted a kind of glow,
felt their smoothness, their coolness,
knowing words were the darker shade of light.

Sitting with the mystery of that,
I took the top poetry book off the stack,
felt its weight in my hand,
wondering if it was the Fargnoli or the Machado,
and understood that words on paper
all weigh the same,
no matter what meaning they impart.

We make such significance out of opposites,
pass laws, impugn one another,
but between hope and despair
there is more light in the darkness
than we ever knew,
a deeper seeing,
a way to breathe from the soul
all the way into the eyes.

What Do I Really Know About Anything?

for John

I know it matters that hours tick along, light swings across the swaying grass, robins hop around the cedar tree.

It matters that I see my neighbor who lives at the bottom of the hill every day, he walking out to the shore as I passed by in my car taking my dog to the park. A tall, thin older man with a thick crop of white locks whose name and business I don't know anything about. Is he married? Widowed? Do grandkids ever come visit? The miles he walks along the beach road matter to the soles of his feet and to his heart pumping blood and the carbon dioxide his lungs feed the trees.

It matters that the sky is wide and the horizon is far and they meet in a realm of perfection that never gets any closer, no matter how far any of us go.

It matters that my children are four-legged and I continue to outlive them.

It matters that night falls gently as a flashlight fading, and that there's a chair by the window that's a comfortable place to read and a lamp whose light is soft as leaf fall.

It matters that leaves flutter away but come back again as buds.

It matters that the ocean sings all of the time and crickets only in summer.

It matters that the water flows freely from my faucet and from the sky every so often, though never too often for me.

I like seeing my neighbor's cat on her covered porch, protected from the weather, a fixture as reliable as the phases of the moon.

It matters that the moon keeps to its tireless schedule, leashed to this fatigued Earth.

It matters that there are cows in the fields and in the barns.

It matters that when I pick up the phone to call you, whether you answer or not, you'll listen to my voice with a smile on your face. That matters most of all.

Artist Studio, Condemned

I want to own the ocean, carry it inside me, soul of persistence, engine of timelessness. Instead, I walk around, grief swirling through my veins. Cut me and I bleed gray. No, you say, impossible but fields of mustard inhabit the past. Somewhere there's a library from which all anatomy books have been stolen. This year the lavender lost its scent and its way. The serenity of salmon is the same river of their birth as their death. My neighbor is building a new porch. Perhaps she'll raise a swing to watch sunsets, like the satisfaction of the second hand on a clock that never stops circling. My father was partial to tapioca pudding with, he requested, *enough whipped cream heaped on top to tickle the clouds.* How can anyone define happiness better than that?

Reasons to Live

Because the sky never wears the same cloud hat twice.

Because the black of crow feathers exudes iridescent rainbows if you pay close enough attention.

Because the wind performs a trillion different arias, and you haven't heard them all yet.

Because the aroma of baking bread is a hug for the inside of your body.

Because the aroma of coffee is a lighthouse guiding you safely from sleep to wake.

Because dipping your feet in the river on a swampy August afternoon is an Ice Age between your toes.

Because ice cream melting on your tongue is a form of prayer.

Because dogs have waggly tails and cats tiny engines of contentment.

Because butterflies are the definition of *anything is possible*.

Because the existence of tardigrades is proof *nothing is impossible*.

Because all of art is a Ferris wheel, and music a mandala of feeling.

Because rain can be soft as a whisper.

Because roses are symphonies for your nose.

Because fireflies are wishes for your eyes.

Because the breeze on your skin tastes of adventure.

Because sand is both silky and gritty, and opposites attract.

Because trees stand watch.

Because the ocean's pulse is ever strong.

Because there are guiding lights in the night sea overhead and a moon boat that steers us calmly into our dreams.

Because a warm smile and a warm hug and a warm mug of comfort await you somewhere. Go there.

Thunder

The dark horse in the late spring meadow
is not a metaphor.

She grazes alone under a trembling gray sky.
Her flanks ripple like a nervous waterfall.
Birds twitter from the mammoth ash tree
behind her in a confusion of song and alarm.
The irises growing along the weathered
split rail fence have not bloomed,
stand like sharp green knives,
a purple absence
in the air heavy with fennel and leaf mold.

By this time next year, someone new
you care for deeply
will lie beneath the grass,
earthworms working flesh into loam.

Think of this dark horse then,
how lightning struck so close.

How the rain always attunes your heart
to a bone of remembrance.

How even a quick crack of thunder
can be received with love.

Cirrus clouds drift by on the horizon
of your empty notebook,
a sky swept clean of any sign of storm.

Caught as I Am in Time

Bright sun is another's joy.
Mine is overcast,
enclosure of soft shadow,

kiss of misty rain.

Within gray light
I breathe with eyes
wide open, deep sight,

no need to squint.

The world is glint
and green and mud,
drought and asphalt.

Salt and caramel.

I've inherited my grandmother's
dulcet hands,
her sense of gentleness,

her gnarled knuckles.

The song stuck in my head
isn't blessed music
but crow caw, dog bark,

the dryer's three-note signal.

When I choose to close
my eyes, there is deep purple
truth, muted echoes

of my own briny pulse.

One shining day I'll be caught
in the amber of death,
time a poetry of undoing.

And this, too, will be love.

broken umbrella

if there are answers
maybe they come after bones are dust

days I want to know outweigh
ones I simply allow forward momentum
to drag me into whatever
messes stresses

my Jewish Romany grandmother sensed
is and *am*
never having heard of Buddhism
said *being alive is enough*

not to believe as she did
feels a broken umbrella
twisted outside in
torn by time

I mourn for tragedies
long before they arrive

a fly abuzz
unable to settle
slow stars like cows
grazing the night meadow

it's spring here
birds winging sideways
to nest building
strangers in the streets singing
tunes under fatal breaths

all blooms will fade and fall
all but ocean's ever-present roar
within earshot

and still I crave more
need more

restless quest to define the meaning
of meaning

distant hills loom like answers
to questions no one ever asks—
> *Dew cools a horizon away*
> *Pools like deep breaths*
> *Fog swallows its own shadow*

shift and decay
dismay
sky never a duplicate

awake in the narrow hours
I fall asleep
lashed to the same dock

rain splashes
rain stitches the earth to the earth

Of the Many Things I Was Taught Not to Do
after Annie Lighthart

I was taught not to repeat anything I saw.

Not the river of night and its luminescent-
eyed fish paddling above me.

Not the fir-covered hills like soldiers
with rifles at ease, finally retreating.

Not the tufted skirts of sky, their billowy
crinoline rustling of maple tree leaves.

Not the waters of the Yaquina, its surface
ripples like the footprints of pale ghosts.

I have lived in so many theaters of the mind
and wanted to kiss and tell all the secret plotlines.

But my mother warned *Loquacious girls go to hell*.

I'm there anyway, so here's what I know—

how mallard's wings flap like urgent letters
fluttering their way to you;

how yellow leaves flit in the breeze like the humble
prayers of very young children;

how earthworms sing in the rain, a nearly silent
song of loneliness;

and love, well, love is the color
of the sky anytime you look up.

How This Poet Thinks

after Patricia Fargnoli

I think like a person with split brain hemispheres,
arctic-blue logical left brain requiring
sense, order, fast-forward,
while my cottony right mind
ruminates at a glacial pace,
indecisive, Möbius, cumulus drift.

I think like a crow stalking the grass,
flapping, jawing, all noise, all nonsense.

Like a koi, poised, a flame
burning beneath the still surface.

Like a hurricane,
gale-force argumentative.

I think like fog cloaking the coastal mountains,
haze that softens the harsh edges of millennial rock.

I think like an earthquake, sudden crash of plates,
friction a driving force.

Like a nimbus cloud, ideas crystalized,
condensation, fluctuation, letting go
of all that falling pressure.

Like a lost doe wandered into suburbia,
missing the shelter of forest overstory,
easy prey for traffic, potshots.

I think like a poet whose words
evaporate in August heat,
whose pen leaks like antiquated plumbing,
whose mind is split like a Thanksgiving wishbone,
neither half lucky
but not unlucky either.

Opera

The voice in my head
is the moon's.
She says the looniest things,
that butterfly wings
are made of spacetime,
and *the eyes of cows
are magnetic north.*

I query her about other
mysteries of the universe
but it's as if she's not listening,
just intones whatever she wants.
*Every fire is the alphabet
backwards.*

Once, the moon woke me
from a dream screaming,
*the windows can't breathe,
the windows can't breathe.*
It's true my windows
are smudged with dirt
but am I murdering them?

When the moon is silent
and my pen reaches
for a metaphor, I mourn
her absence—she will
not come when summoned.

My stomach growling
long after dinner,
the moon calls out
over the noise,
the stars are sweet as sugar.

As I am wandering,
lost in unanswerable
quandaries,
the moon reminds me,
*each blade of grass
is its own encyclopedia.*

The crow is a magician of night sky,
she whispers as I lie awake
in bed, unable to unsquelch
the volume of silence.

If there is a pattern
in the randomness
of her revelations,
I've yet to uncover it.

When I'm feeling grumpy,
I hear, *mountains are jealous
of the birds, the wind
is envious of the trees.*

I want to see the world
with the moon's
romantic vision
but it's difficult
to reject science.

*Moths are the guardians
of starlight.*

*The sea is gravity's
true love.*

Rain is God's opera.

The Joy of Words

Simple words: *bird, salad, wedding, dog, log.*
Music insists on itself in the consciousness stream.
A dream where language composes
the shapes of imagination.
Railway-station phrases illustrate scenes.

Once there was an abstraction and all of humanity
sought to fill it with concrete.
But the aggregate would not set, not let
love, or beauty, or cold, or fear, or hunger
answer to one definition, one master.

To cast a word in bronze may be tempting.
But what about time, change-maker, breaker,
evolver, devolver, reimaginer?

Today I write the word *breeze* and it means gentle.
Tomorrow, when the nuclear winds blow,
or the coronavirus-stricken crowds rush in,
breeze as we know it, will mean death.
How can we make any permanent mark on the soul of art?
The mind is fickle, and humankind does not hold to
any one truth.

Wonder is transitory and changeable
as states of matter in the universe.
First, *all* is a point of infinite mass.
When that implodes, gas and gravity and matter
disperse into chaos.

Nothing's the matter with loving the way
one word follows another,
cowbells in the pasture on William Duffy's farm.
Else, drops of rain clattering
like nails against the windowpane.

Poets possess no exclusive license on love.
Similarly, pain.
The robin collides with your kitchen window
unknowing how stunning glass can be,
the window invisible even to itself.
How seldom we praise the imaginary made real.

How a feeling is something neuroscientists can
electrify into the brain.

How the speed of thought defies Einstein's
speed of light upper limit.

How the scope of joy is immeasurable.
Or is it the height or weight or texture?
Or perhaps the reflective melody?

Meaning is its own cage.

Let the page exist on higher planes than the three
or four dimensions we humans can trace.

Let us taste the multiverse a poem is.

Let us suck the marrow of hieroglyphs letters can be.

Let focus dissolve.
Let us lose ourselves in the maze of patterns
across the page until only our hearts can read them.

Why I Write

The person-sized dog who sleeps between
my husband and me each night can no longer
jump up onto the bed on her own.
She tries and fails, so I leap out behind her in the dark
to catch her back legs and propel them up the moment
her front legs make the attempt.
I write because I don't know whether this is a mercy.

I write because the autumn air smells of leaf rot and
cinnamon today,
and the aroma of my husband's coffee that I am
doctor-forbidden to drink causes a longing in me
that croaks like a horny spring toad.

I write because my father had overcast-sky eyes
and a nose broken too many times.

I write because the only time my brother told me
he loved me was the day before
leukemia claimed his life at age fifty-three.

I write because the rain needs an advocate.

Because we still kill brown skin.

A flutist once said there's a tenuous balance between covering
and uncovering the holes to create
beauty in the music.

I write because the moon uses time like its personal
chauffeur.

Because the night's a cracked mirror in which my face is
absent.

I write because the white moth that alights on the window
above my desk displays papery wings that are pathways to
other realms.

Because the cinema of daylight releases a new blockbuster
every hour.

I write because my cat's paws tap secret Morse code messages
across the wooden floors.

Because I have my grandmother's hands,
her clumsy thumbs,
and there's ink in my pen,
pages like unspoiled fields begging
for the boot prints of words.

I write because a woman's womb is not inventory.

Because hope is not a sold-out event.

Because heartbreak is as common as birdsong
but as complex as frost patterns in the woods
on a new-moon eve.

I write because my mother was an alphabet of pain.

I write because the storm battering the roof
patters more softly than the regrets
that echo in the canyon of my memories.

I write out of love.

Wings of Desire

after the film by Wim Wenders

The angels are suave and severe in their perfect
Burberry trenches, favoring altitude and silence.

All they do is witness.
As if that could ever be enough.

Poetry passes through them, inert as argon.
Attitude is a poor substitute for empathy.

Let them whisper all they want.
All I ever hear is shadow.

What's the point of sending photogenic
angels to spy on us humans?

If God wants to know something,
let her come herself, crack open the sky.

If God were Nick Cave, the world
would rhyme with orange.

If God were a trapeze artist, we'd all
be graceful and look good in tutus.

One thing's for sure, no angel was ever
as cool as Peter Falk in a rumpled raincoat.

Reunion

after the painting by Andrea Kowch

Outside the train window,
a tempest of birds the color of midnight,
moon glowing polar.

On my way to a place I hadn't been back to
in a long time, for good reasons I believed.

The gift I carried could just as well
have been an empty box.

My dog, loyal to the idea of home
as a person, beside me for the journey.

I didn't know what to hope for,
feeling a circuitousness of angst and desire.

Nothing could be heard from other passengers,
so quiet, I propelled my mind to the last time
I was happy in the place I was headed—

a blazing sunset bled the horizon to dark,
fireflies in the vacant field at the end of the lane
like landlocked stars,

me staring into the flickering,
you a warm breath on my cheek.

No Jars: A Life Story

After nearly six decades, I am still a colony of ants swarming a spill of honey, gold and golden in a patch of sunlight.

Still the girl who checks the mirror for ghosts, especially behind the eyes.

In childhood's yard, fireflies cavorted amid the yellow puffs of the forsythia bush. I never subjected any to jars.

What I remember: icicles dangling from the eaves dangerous enough to pierce; a small sailboat whose sea was the neighbor's concrete driveway; my hair never long enough for braids; the Vietnam War as dinnertime entertainment.

I once hurt someone by mentioning his mother's smooth hands.

Windburn stings more than sunburn.

In San Juan, a flying cockroach dive-bombed my mouth.

Married in a dank cave hundreds of feet below the surface of the earth, divorced in a fluorescent courtroom on the third floor.

I can't recall my grandmother's voice or the last time I smiled.

I'll never forget the bedroom above the restaurant where our sex smelled like stir-fry.

Every rainstorm is welcome.

Ocean waves teach tolerance, forests patience.

Aging is an umbrella in a windstorm.

Even now, the best words to describe me are heartbroken, lobelia, starlit.

Love Is the Key to a Luscious Apple Pie

Rumor has it the night sky
is composed of crows,
wings wide in flight,
a puzzled-together Escher drawing.
The lights we see, their glowing
eyes, and where there is darkness,
their nictitating membranes
remain closed.
I have never flown
close enough to know,
to stroke their nimble feathers,
nor will I.

Down here on the ground,
at the bottom of the atmosphere,
they say time is imaginary,
made up by men to explain
how love withers,
though not why.

If this is one universe of many,
perhaps there is a place
where aging
is a rumor never proven.

Here in the Milky Way,
losses amass
like ants upon fallen
crumbs.

My sink is full.
My tank is empty.
If my mother were an oyster,
why am I not a pearl?

I step between shadows
wondering whether wind
is the breath of God.

When I pass a cemetery,
I hold my breath,
death being contagious.

I have wanted to love everyone
and failed:
my neighbor who mows his lawn
at 5 a.m. on Sundays;
the mugger who beat
my grandmother into a coma;
our reality-TV president;
men in blue who view
black and brown skin
as invitation to do evil.

It's difficult to follow
advice or ethos
but here goes—
Measure twice, cut once.
Cut it out.
Be kind to spiders.
Always carry an extra pair.
Fold love into the pie filling.
Dip your lips in honey
before kissing goodnight.

A Blue True Dream

after E. E. Cummings

I who have died live again
 among alder leaves
 waving in the wind between
 raindrops light as moth wings
 beneath fallen limbs
of cedar where beetles hide.

Every particle of light
 crackles too softly to hear
 without hearing a sigh.

You and I pass through each day
 as through a gate
 unknowing when it might sometime
 lock us out.

For now, there are rivers of tree bark
 lifting toward heaven
 greened banks above water flow
 going slowly nowhere
 water doesn't already go.

Let us taste the soil with our eyes.
 Let us inhale sky
 with our hearts.

Nourishment courses from Earth
 through our veins
 as *yes* and *yes* and
 illimitably *yes*.

The Universe Is Made of Space

Do you see the space between our bodies?
 —Li-Young Lee

Our Earth, too, space, space, space.
Jungles dense with green—space.
Cities jammed with brick and blacktop—space.

Space outside, space inside of being.
Space invisible as warm breath
on a sultry evening.

Any creature can sense the vastness
between the scent of honeysuckle
and the buzz of the hovering honeybee.

Not the End of Poetry

after Ada Limón

Shower me with susurrus and hummingbirds,
with cherry blossoms and Steller's jays,
with acorns and pine needles, leaves and roots,
more impasto, more of *still* and *perhaps*,
more witty librarian and *awake* and a moment's
grace, more of flesh and ache, desire and divine
remembering, and the heavens and ice floes,
sorrow, more of everything the pain is like and not
like, how someone's absence changes the light,
more of the pledges and denials and studying
the sky and searching one's heart, more of the flare,
the flash, a best friend's death and the letter she
hid for you in a shoebox, more of the hunger
and craving, the self-doubt and all of suffering, more
of lost childhoods, grandmothers and grandfathers,
more considering the world, curious and passionate,
more of the difficult to look at without looking away,
more *please listen, I am here*, more *we are in this together*,
more of your voice mingling with mine, more nights,
stars, moons, rain glow, gratitude and its gifts, more joy,
I am asking you to write more poems.

Creed

after Wendell Berry's "Manifesto"

I have sworn prayers
in the chapel of poetry,
a faith whose answers
abound in every language,
whose questions,
abundant as rain,
fertile the earth.

Each morning, my waking prayer
is different.
Today Wendell Berry tracks the page
with fox paws,
and before I go to sleep tonight,
my own tired hands will muddy
the notebook with nearly illegible
hieroglyphics about serrated crows'
wings shredding dusk.

Faith is a metaphor
for ocean,
but also, a simile
for sorrow.

This afternoon, seated in the last pew
of the forest,
cedar boughs wave their needled branches
against uncompromising sky,
like beseeching arms of yet another mother
whose child was felled by violence.

I wonder if I have chosen
my religion wisely.
Fidelity to the images words create
makes me vulnerable to hope.

The air howls and pounds
and I can't tell if it's the wind
or the sound my heart
throbbing in my head.

The news is grave.
Sunlight seems like forever.
Earth will survive us,
heal for millennia,
until the scars humanity made
are greened over.

For now, all I want to do
is pray day and night:
Pablo Neruda, Emily Dickinson,
Warsan Shire, Langston Hughes,
Alison Luterman, Patricia Fargnoli,
Richard Blanco, Maya Angelou.

I want to trust
in the art of language,
how remarkably words mirror
our unbearable beauty
that struggles yet rises and rises
to the surface of love.

River Light

grief and grit
and still the moon above

still the moon path
flowing across the river
like a raft

save yourself
in the quiet hours
one kind word at a time

Things You Will Only Learn About Me When It's Too Late

Listen to me as one listens to the rain.
—Octavio Paz

I wanted to grow up to be an astronaut
so I could escape the gravity of childhood.

My first crush was on the winter night sky.

In a crowd of people, mosquitoes bite me first.

Sleep was never a friend.

Barbie, a sworn enemy with her wasp waist
and long, straight blonde locks.

My dark hair never grows much below my ears.

Hula-Hoops and I reached a discordant truce.

I failed at everything,
some things more than once,
some things hundreds of times.
This hasn't stopped me trying.

The forest canopy is my adopted family.

Coffee is a verb.

Poetry is breakfast.

My heartbeat aligns with Atlantic Ocean's pulse.

Klutz, I have spent my entire life falling.
First, in love with shadow, then chiaroscuro.

Once, I pitched down a hill in a city park,
would have kept rolling forever except my head
collided with a cedar tree and stopped me—
thankfully the tree was unharmed.

I trip over words, especially *goodbye*.

I fell into mathematics as a major in college
and am still solving for x.

I stumbled into the oblivion of Earl Grey
ice cream and never stumbled back out.

I teeter on the seesaw of self-love
with a fulcrum of constant panic
that balances things out nicely.

My life story is the autobiography of rain.

Acknowledgments

The author wishes to acknowledge and thank the following publications where some of the poems in this collection previously appeared, sometimes in earlier versions.

Amethyst Review: Thin Places & Sacred Spaces: "Second Light"

The Big Windows Review: "Landscape in Dresses"

The Bluebird Word: "House Hunting"

The Broken City: "Wings of Desire"

Buddhist Poetry Review: "Every Hour," "The Joy of Words"

The Disappointed Housewife: "Grief Rhymes with Yellow"

Dodging the Rain: "Window in Late January"

Exterminating Angel Press: "Every Hour"

Fireweed: "broken umbrella," "How this Poet Thinks"

GAS: Poetry, Art & Music: "Things You Will Learn About Me After It's Too Late"

Global Poemic: "Another Coronavirus Spring"

Green Silk Journal: "Why I Write"

Iodine: "Howe Farm Dog Park, December"

Journal of Expressive Writing: "What the Sheltering Do"

kerning / a space for words: "No Jars: A Life Story," "Pyramids"

The MacGuffin: "no one said it wouldn't be hard"

Naugatuck River Review: "The Red Suitcase"

The North Coast Squid: "Immovable Clouds"

Peregrine: "Ode to My Steller's Jay," "Shivering"

The Poeming Pigeon: "become sea become sand become sky," "'Poetry Reveals There Is No Empty Space'"

Poetry Breakfast: "Caught as I Am in Time"

quartet journal: "On the Nature of Grief"

Quill & Parchment: "Imagine," "The Starry Night"

Rattle: Poets Respond: "Twenty Twenty"

The RavensPerch: "Let's Play the Game"

RockPaperPoem: "Psalm"

Sheila-Na-Gig: "Abyss After Tea," "Reunion"

Snake Nation Review: "'In the Distance People Are Making Even More Distance'," "Love Is the Key to a Luscious Apple Pie," "Wonder"

South Shore: "No Matter What"

Split Rock Review: "Thirteen Ways of Looking at the White Moth at My Window"

The Timberline Review: "A Blue True Dream"

"Anti-Ode to Chicory Root Beverage" and "Creed" appear in *When All Else Fails*, The Poetry Box, 2023.

"Artist Studio Condemned" and "Not the End of Poetry" appear in *Overtures*, Kelsay Books, 2023.

"For Rainy Day, My Greyhound" appears in *The Dead Pets Poetry Anthology*, Transcendent Zero Press, 2023.

"Landscape in Dresses" was nominated for a Pushcart Prize by *The Big Windows Review*.

"Not the End of Poetry" appears in the pandemic anthology *In Isolation*, Alternative Field, 2022.

"Thunder" appears in the anthology *Mindful Poetry Moments*, The Well, 2021.

"To the Art Teacher" was made into a video with music and art by my nephew, talented writer, director, and producer Max Hechtman.

"The Shovel" appears in the anthology *Purr and Yowl: Cat Poems*, World Enough Writers, 2023.

"The Well of Grief" appears in the anthology *Oxygen: Parables of the Pandemic*, River Paw Press, 2022.

"Why I Write" received Honorable Mention in the 2022 Kay Snow Awards.

"Wonder" also appears on a broadside paired with the art of Rick Crawford in the 2022 Word & Image Series sponsored by the Hoffman Center for Arts in Manzanita, Oregon, and is reproduced in a catalog of the exhibit.

Gratitude

An epic thank you to Eric Muhr and the entire staff of Fernwood Press for expertly ushering *The Autobiography of Rain* into the world.

Abounding gratitude to internationally acclaimed artist Andrea Kowch for allowing her painting *Reunion* to grace the cover of this collection. And, special thanks to everyone at the RJD Gallery who helped make that happen, especially Richard Demato.

This book would not be possible without all the creative, kind, and caring people I am lucky to have had in my life—

Heartfelt thanks to my loving husband Andy who has always been a steadfast supporter of my work.

Deepest gratitude to my Friday Scribes—Brian Atchison, Sherry Green, Deborah Hobbie, Brendan McBreen, Kim Mounsey, Kitt Patten, and John Wood—who enrich my life on a weekly basis with the beauty and power of their words and friendship.

Sincerest thanks to the folks in Poetry Book Club who broaden my mind and open up new vistas of appreciation within me.

Immense gratitude to the First Wednesday Monthly Meetup writers who play along with my prompts, and whose work inspires, awes, and uplifts.

Profound thanks to Dana Cunningham Anderson for the generosity of her Writing Alive Workshops and to all the participants I've written with in them. Several of the poems in this collection were born in those gatherings.

Limitless gratitude to Debra Elisa for Thursday Poetry Play and also to Sharon Carter, Glenna Cook, Paul Hosea, Carolyn Peck, Yvette Raynham, and Peter Wood who all play along. A few of the poems in this collection began there.

Boundless gratitude to Jane Brunette whose lavish listening and Buddhist counseling cleared the way for me to produce some of my best work.

Bottomless thanks to all those who have given me airtime in their poetry venues, especially Sandy Yannone—I could not ask for a more generous and steadfast champion of my work.

Tremendous thanks to Kelli Russell Agodon, Oliver de la Paz, Matthew Dickman, Catherine Kyle, and John Sibley Williams for their lovely endorsements of this volume.

Cheers to Ellen Bass, John Brehm, James Crews, Matthew Dickman, Ilya Kaminsky, Danusha Laméris, Joan Larkin, Annie Lighthart, Alison Luterman, Anne Marie Macari, Tim Seibles, Kim Stafford, Maya Stein, Laurie Wagner, Michael Waters, John Sibley Williams, Cecilia Woloch, and Carolyn Wright whose workshops, seminars, and/or Yogic wisdom encouraged me to stretch my poetry muscles to previously unimagined heights and lengths.

Infinite gratitude to Kate Gleason for introducing me, back in my New Hampshire days, to the Amherst Artists and Writers Method created by Pat Schneider. This method has been my saving grace ever since.

Everlasting thanks to my third-grade teacher Mrs. Pearl Sarfaty who kissed fuchsia lipstick wings on my cheeks and dubbed me a *poet*.

Endless appreciation to Ottone "Ricky" Riccio who welcomed me at the threshold of poetry and ushered me across. I brought a three-page poem to the first day of his workshop at the Boston Center for Adult Education and left with three lines intact. I gratefully participated in his workshops for over a decade and learned multitudes about craft.

My heart hurts over the death of Patricia Fargnoli, to whom this collection is dedicated, an early poetry mentor who became my faithful cheerleader and dear friend. She encouraged me to send my work out into the world. Without her this book would never be.

About the Author

Lana Hechtman Ayers, originally from New York, settled in the Pacific Northwest after a decade in New England. She is managing editor of three poetry presses: Concrete Wolf Poetry Series, MoonPath Press, and World Enough Writers. She facilitates generative writing workshops in the Amherst Method, runs a poetry book club, helps other poets assemble manuscripts, and teaches at writers' conferences.

Lana earned BAs in Mathematics and Psychology, holds a Masters in Counseling Therapy, and possesses MFAs in Poetry and in Writing Popular Fiction. A Best of the Net, Pushcart Prize, and National Book Award nominee, she won honors in the Discovery / Nation Award and in the Rita Dove Poetry Prize. She was awarded writing residencies from Hedgebrook, Devil's Tower National Park, and The Whiteley Foundation.

Lana is the author of ten previous collections of poems and chapbooks, including: *Overtures* (Kelsay Books, 2023), *When All Else Fails* (The Poetry Box, 2023), *Red Riding Hood's Real Life* (Night Rain Press, 2017), *The Moon's Answer* (Egress Studio Press, 2016), *Dance From Inside My Bones* (Snake Nation Press, 2007), winner of the Haas Award, and *Chicken Farmer I Still Love You*

(D-N Publishing, 2007), winner of D-N's annual award. She published a romantic time travel adventure, *Time Flash: Another Me*, and is currently writing its sequel.

In addition to thriving in the book-loving culture, Lana enjoys the Oregon Coast's bountiful rain and copious coffee shops. She lives with her marvelous husband and several sweet fur babies in a town famous for barking sea lions. Lana enjoys cryptograms and watches entirely too much British crime television. Her favorite color is the swirl of Vincent van Gogh's *The Starry Night*. Visit her online at LanaAyers.com.

Title Index

A

A Blue True Dream ... 106
Abyss After Tea ... 69
After you hung up on me 22
Another Coronavirus Spring 46
Anti-Ode to Chicory Root Beverage 71
Artist Studio, Condemned 85

B

became sand became ocean became sky 37
broken umbrella .. 91

C

Caught as I Am in Time 89
Creed .. 109

D

Dispelling the Mystery ... 30

E

Elegy for Tenderness 20
Every Hour ... 39

F

For Rainy Day, My Greyhound 64

G

Grief Rhymes with Yellow 23

H

House Hunting ... 76
Howe Farm Dog Park, December 51
How This Poet Thinks 94

I

If I Carry My Mother 53
Imagine .. 34
Immovable Clouds .. 19
"In the Distance People Are
 Making Even More Distance" 25

L

Landscape in Dresses 27
Lazy Ode to My Husband of
 Thirty-Some-Odd Years 73
Let's Play the Game 55
Love Is the Key to a Luscious Apple Pie 104
Love Poem with Soup 75

N

Need to Know .. 65
Nineteen Things No One Knows about Me
 (And One They Do) 14
No Jars: A Life Story 103

No Matter What .. 70
no one said it wouldn't be hard 50
Not the End of Poetry 108

O

Ode to My Steller's Jay .. 61
Of the Many Things I Was Taught Not to Do 93
On the Nature of Grief 58
Opera .. 95

P

"Poetry reveals there is no empty space" 80
Psalm .. 67
Pyramids ... 42

R

Reasons to Live ... 86
Reunion ... 102
River Light ... 111

S

Second Light .. 81
Shivering .. 38
Strong Verbs .. 56

T

The Joy of Words .. 97
The Red Suitcase ... 29
The Shovel .. 63
The Starry Night ... 36
The Universe Is Made of Space 107
The Well of Grief .. 68
Things You Will Only Learn About
 Me When It's Too Late 112

Thirteen Ways of Looking at the
 White Moth at My Window 31
Thunder ... 88
To the Art Teacher ... 16
Twenty Twenty .. 59

W

What Do I Really Know About Anything? 83
What the Sheltering Do 48
Why I Write ... 99
Window in Late January 21
Wings of Desire ... 101
Wonder .. 18

First Line Index

A

After nearly six decades, I am still
 a colony of ants swarming a 103
All through the night she left us, the stars 56
As soon as I open the window 46
At MoMA in New York at eighteen 36
At the cabin in Pemaquid, Maine 37
At the click of leash release 51

B

Bastard step-cousin of coffee thrice removed 71
Because the sky never wears
 the same cloud hat twice 86
Bright sun is another's joy 89
Brother, my freezer—arctic 48

D

Dawn began with the sight 39

G

Glimpses reflected in mirrors 27
grief and grit ... 111

I

I am the moon's dark side 70
I call you mine .. 61
I can hardly imagine it 65
if there are answers ... 91
I gave the moon my cold shoulder,
 trembling it was .. 22
I have sworn prayers 109
I hope it is little more 53
I know it matters that hours tick along,
 light swings across the 83
I once had a brother who was
 a distant planet. Clear winter 14
I only discovered the web once I was home,
 washing my hands 67
I rise in the still shadowy house filled 38
Irritable in my office chair over
 a mistake that's too late to 42
Is it a trick of shadow 64
I think like a person with split brain hemispheres 94
It is always hard. The pickle jar
 that's hermetically sealed 50
It is not the bufflehead floating
 on the pond that dives 58
I wanted to grow up to be an astronaut 112
I want to own the ocean, carry it inside me,
 soul of persistence 85
I was taught not to repeat anything I saw 93
I who have died live again 106

J

 John Lennon speaking softly 34

L

 Last night, after I turned on one lamp too many 81
 Late morning throws shadows at odd angles 30

M

 My father's eyes gray haze 55

N

 no roses, I'm afraid ... 73

O

 Our Earth, too, space, space, space 107
 Out of the void: dishes, dust, screens,
 fire fight, firefly .. 80
 Outside, snow falls like a dream 19
 Outside the train window 102

R

 Rumor has it the night sky 104

S

 Shower me with susurrus and hummingbirds 108
 Simple words: *bird, salad, wedding, dog, log.* 97
 Sky above ..18
 Snow today in this place 21
 so green is the leaf ... 23

T

 The angels are suave and severe in their perfect 101
 The blender pulverizes 75
 The dark horse in the late spring meadow 88
 The hole outside the sunroom 63

The orange klezmer music of sun 68
The person-sized dog who sleeps between 99
The voice in my head ... 95
The white moth was ... 31
This was the year breath became death 59

U

Uncapturable in the past 20

W

We are all disappearing into history 69
We're looking for something spacious 76
We were going to live forever 29

Y

Years ago, I volunteered weekend 25
You ask me to draw the breeze 16

www.ingramcontent.com/pod-product-compliance
Lightning Source LLC
Chambersburg PA
CBHW010045090426
42735CB00020B/3398